**PHOTOGRAPHS**
**TOM SHEEHAN**

**ESSAYS**
**SYLVIA PATTERSON**

For
Jamie, Alex and Florrie X

With thanks to:
Carl Glover
Sylvia Patterson
Joe Cottington
Adam Powell

TS 2025

# CONTENTS

# INTRODUCTION

I was lucky enough to work with Oasis before everything went crazy for them. My first encounter with the brothers was in July 1994, on a trip to New York the month before *Definitely Maybe* was released.

I had actually met and happened to photograph Noel some time before that, just one frame taken in January 1994. It was the morning after Oasis had played a gig at The Water Rats, in Kings Cross, their second show in London. Still very much the early days.

I was at Abbey Road Studios to photograph Ride featuring Andy Bell – later to join Oasis, of course. We were listening to some of the mixes my old chum producer John Leckie was working on for Ride's *Carnival of Light* album. Andy had been raving about this new band Oasis for a while, and he had been to see the show the night before. He invited Noel down to the studio the next day, I guess because of the Beatles connection, Noel being such a fan.

I'll happily chat to anyone, so Noel and I got talking about leather jackets, of all things – he had on a Levi's-style jacket, I had something similar. I took this snap of three Creation label mates, Idha (singer and Andy's then wife), Andy and Noel on the sofa. That evening, Alan McGee came by with a tape of some Oasis demos and played them for us. He asked me what I thought. "Knee-deep in swagger, old boy," I replied.

That swagger is something they have carried through their career, which I've really enjoyed. Some people have called it arrogance, but to me it was just a self-belief in what they were doing. Oasis were a breath of fresh air. Their music, their stage presence, their public persona, all of that malarky Liam came out with, usually rooted in truth and pretty hilarious. I thought they were great.

I remember when I met Liam, on the plane over to New York on that first trip together. As we were chatting, this lady came by with her little kid and wanted to use the loo. You can't really squeeze a kid into one of those tiny plane loos with you, so Liam offered to look after her little one for her. As he sat there on this fold-down seat, bouncing this little kid on his knee and talking to them, I thought, "Hold on, he's supposed to be this mad rock 'n' roller!" He is to some extent, of course, but he's also a thoroughly nice guy.

We got on well straight away. The band seemed to have a similar attitude to me: they welcome everybody but if you're an arse, then the door's over there, mate.

In those early days they were still working out their style. You can see that they were striking a pose from day one, that swagger and confidence. But their overall look was still up in the air. Knowing that they worshipped at the altar of The Who, when I first shot the band on that New York trip I suggested to Noel that we try to recreate the famous Art Kane shot of The Who sat on the floor, draped in the Union Jack, but using the stars and stripes instead. Noel thought that was a great idea, and said that he spread a Union Jack over his amp when he played, so why don't we use the two? I thought, perfect, a match made in heaven! So the idea came fully formed, and one of the first shots I took of the band has ended up being one of my favourites.

The band were bringing guitar music back to the masses, something that was needed at that time. Before Oasis had come grunge, and how many of the records of that era remain vital now? You could probably count them on the fingers of one hand. It was a different kind of music, and enjoyable – but rock 'n' roll was invented for a reason. It shook things up. You could tell that's what Oasis were doing from day one.

Tom Sheehan

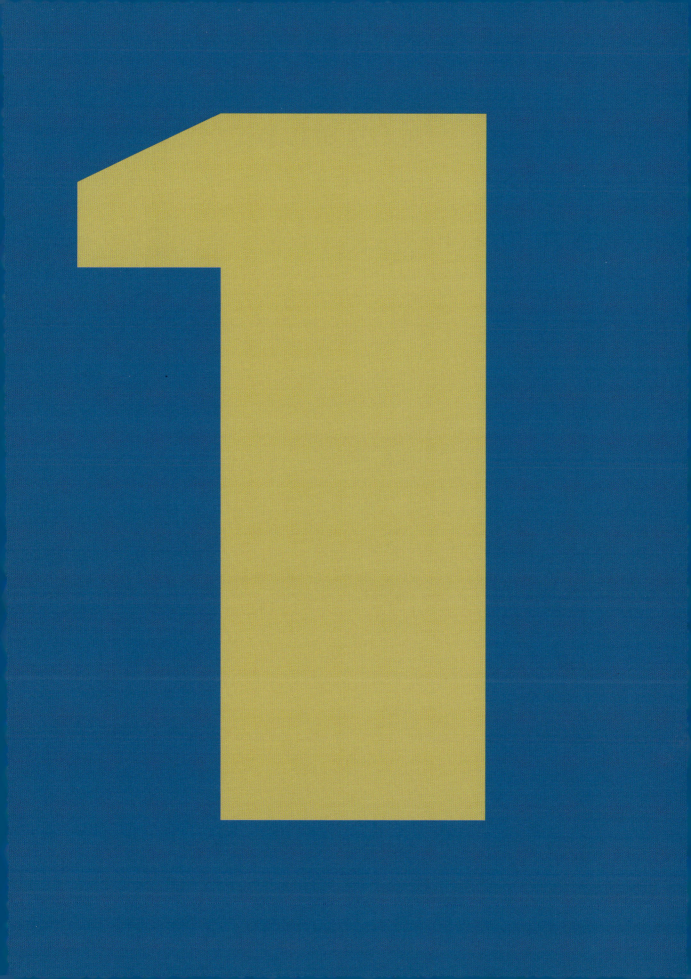

# THIS TOWN HOLDS NO MORE FOR ME

Burnage, Manchester, summer 1984. The bedroom Noel and Liam share in the Gallagher family's council house is basic. Two single beds, a stereo, no fancy fresh paper covering the walls, only the faded, semi-stripped remnants of previous tenants still visible. Their mum, Peggy, can't afford new wallpaper: an Irish immigrant who's been living in Manchester since 1961, she's worked variously as a cleaner, a dinner lady and a biscuit factory worker plucking misshapen Penguins and Jaffa Cakes off the McVitie's production line. Noel, just turned 17, and Liam, about to turn 12, make their individual marks on the threadbare walls – football posters for Liam, band posters for Noel, while both scribble the sacred words "Man City". From the upstairs windows of their previous home they had been able to see the sparkling, silvery floodlights of their boyhood theatre of dreams, Manchester City's Maine Road stadium.

Forced into this small, confined space they rub along reasonably well, bar the odd brotherly physical fight (oldest brother Paul has his own room), though in two years' time, on the night Liam embarks on his inaugural bender on the booze, he'll fail to find the toilet and piss all over Noel's brand-new stereo instead. Noel will go ballistic – and a lifelong feud begins. They're here because Peggy's just moved them here, to save her boys, and herself, from Tommy, their violent alcoholic father who's been beating up Paul, Noel and Peggy for years. Liam is the only family member who is untouched – but only because, in the worst years, Liam was under seven and a beating might have killed him. The traumatised Paul and Noel had developed stammers (eventually corrected by years of speech therapy) and in 1984 Peggy walked out on Tommy overnight, leaving him with a knife, a fork, a spoon and a blanket.

Beyond the red-brick terraced street of Cranwell Drive not much is going on locally – there's a pub, a chip shop and a bookie's – in the era of mass unemployment, the miners' strike and no-such-thing-as-society in Margaret Thatcher's industrially decimated Britain. But inside this modest room a young man with a head bursting with limitless dreams is quietly starting a revolution from his bed. Inside this room, ideas for songs are forming that will define a generation exactly ten years into the future. They've been forming for years already, ever since Peggy gave Noel his first guitar aged 12, from a Kay's catalogue, and he found his life's salvation. He'd learned to play from a Beatles songbook and was soon a dedicated follower of not only The Beatles but their fellow 60s pioneers The Kinks and The Rolling Stones, alongside the spectrum of 70s titans, from T. Rex and David Bowie to the Sex Pistols and Slade, to the new heroes of the early 80s, The Jam and The Smiths. In 1984, like Andy Dufresne in *The Shawshank Redemption*, Noel is patiently chiselling his tunnel towards the light, through songs of escape, freedom and hope, songs of friendship, hedonism and heroism.

"When I was a teenager, I romanticized everything," Noel tells *The Big Issue* many years later. "*Top Of The Pops*, football, going to gigs, records, girls. I didn't know it at the time, but I was already laying the groundwork for what I would become – an artist, a romantic."

He stays in most nights with his guitar, writing songs, alone, while his little brother is permanently out.

"I was never in me house," Liam tells me, in a rare, reflective solo interview in 2007. "I'd get up, go to school, be out till ten playing football, havin' it, just a load of lads in the park. Some of 'em sniffing glue, some of 'em drinking beer, cider, mushrooms, whatever, just fucking about, sitting on the bowling green, drinking. Top."

While Noel is diligently crafting what will become one of the best-loved songbooks in musical history, Liam isn't interested in music, thinks music obsessives, including Noel, are "weird bastards", and instead dreams of becoming a footballer, "but if not that, I'd get a job like a butcher and just sink into normal life." At 15, the year he leaves school without taking a single exam, Liam briefly works in a garden centre, until he's asked to clean out a Portakabin toilet. Appalled, he never returns and signs on the dole instead. That year, in a rival school punch-up, he's hit over the head with a hammer, wakes up in hospital with a headful of stitches and starts to hear music properly for

# 1984–1994

the first time, likening this post-traumatic experience to "when people wake up from comas and speak Japanese."

At 15, Noel is forced to leave school, expelled for his burgeoning "career" as a petty criminal who'd robbed corner shops and thrown flour over a teacher. He signs on the dole between jobs in construction, then a British Gas storeroom, where an accident proves the pivotal point of his life: a huge steel cap attached to an enormous gas pipe falls onto his foot, smashing it to pieces. "When I came back from the sick," he tells Q in 1996, "they gave me a cushy job in stores handing out bolts and wellies. Nobody would turn up for days on end. After about six weeks I started bringing me guitars in and I wrote four of the songs from [*Definitely Maybe*] in that storeroom. I look at this foot sometimes in the winter when I get chills in it because of the cracked bones, and I go [thumb aloft, crinkly-eyed grin at dodgy foot]." From those days onwards, he adds, "all I was interested in was music and escapism".

By 1990, 17-year-old Liam is a Stone Roses devotee, discovering The Beatles, Hendrix and The Who, finding in music his own escape from the fractured, violent home he grew up in. "Me mam was great, she looked after us all, but it was shit at home and I needed to get in, not a gang, but a group of summat," Liam reflected. "And the first band I saw was the Roses and the Roses took me away from it. I thought, 'There's a place there, that I can go and be part of.'"

Romance. Escape. Belonging. From these touchstones Oasis is formed, firstly by Liam's mates in a band called Rain – Paul "Bonehead" Arthurs (guitar), Paul "Guigsy" McGuigan (bass) and Tony McCarroll (drums) – who sack their first singer, enlist Liam instead, who changes their name to Oasis, and who then "let" Noel join after he sees their first-ever show at the Manchester Boardwalk in August 1991. For years Noel has been a roadie for Manchester's Inspiral Carpets, still doggedly writing those songs, constantly on the road, where he listens to his homemade compilation tape of Slade, Bowie and T. Rex, craftily copying the guitars for his own songs – a dastardly ruse with thrilling results.

"I goes down, about 30 people there," Noel tells Q of the Boardwalk debut. "They did four of their own songs. I know I've said they were atrocious, but they weren't that bad. I thought, 'Our Kid's got summat about him.' They came off stage and he went, 'What did you think?' 'You're alright, but you've got no tunes.' And he comes back with, 'Well, it's more than you ever fuckin' did – you've got loads of songs and you're sat on your arse being a roadie. Don't you slag my band off!'"

Liam asks if he fancies a jam. Noel fancies a jam. Soon, he begins playing his own songs, at Liam's request, and "the lightbulb", as Noel calls it, not so much immediately switches on as flares overhead like a coronal mass ejection from the sun.

Early April 1994, and across planet pop the dominant guitar-led force, since 1991, the year Oasis formed, remains glum-faced US grunge. Nirvana's songs are one thing, with their raging anthemic energy, the rest of it an anti-pop, anti-fame, anti-glam phenomenon fuelled by Prozac, heroin and suicidal torment should your band sell more than three singles. Over in the UK the best we have to counter it is Take That, who are always No. 1, reggae scamps Chaka Demus & Pliers and Wet Wet Wet on their way to No. 1 with "Love Is All Around", which will stay there for approximately three decades.

The general public know nothing of new Manchester band Oasis, who've been signed to Alan McGee's Creation Records for less than a year, since a double-chance encounter on 31 May 1993 in King Tut's Wah Wah Hut in Glasgow. McGee was only there because he'd missed his train back to London. Oasis had barged onto a bill they weren't even booked for.

On Saturday, 9 April 1994, however, the tectonic pop plates are rumbling underfoot, and a volcanic eruption is about to thrust through the cultural crust to reconfigure the landscape forever. It's late morning, *The Chart Show* is on, and a head appears onscreen, a strikingly attractive head with a Mod-U-Like haircut, succulent lips and enormous deep blue eyes unblinking through tinted circular glasses. A curious guitar sound peals out, like an inner-city urchin

rattling a stick along an iron railing, as this beautiful young man begins to sing, like a mewling, prowling panther, something about needing to be himself…

That very morning news breaks throughout the world of music that Nirvana frontman Kurt Cobain has killed himself. Two days later, on 11 April, Oasis' debut single "Supersonic" is released and goes straight into the Top 40 – a song written, Noel will insist, in the time it takes to hear it.

In a single act of violent self-destruction, the early 90s are finished, overnight. That same April, in the weeks following "Supersonic", new lights are sparkling through the darkness, crackling into life in the cosmos overhead. Sometime peripheral indie kids Blur release their third album, *Parklife* (and begin wearing Union Jack-motifed blazers); kitsch-pop cul-de-sac dwellers Pulp, getting here since 1979, release their fourth album, *His 'n' Hers;* while newly adored indie-glam hobos Suede will release their second album, *Dog Man Star*, in October – in the year when a brand-new word is unwittingly hung around their collective necks: Britpop.

It's Oasis, though, who blaze brightest at the centre of this newly star-burst constellation: their second single, "Shakermaker", is a No. 11 summer hit featuring its audacious steal of the New Seekers' 1971 milkman-whistler "I'd Like To Teach The World To Sing" (which will eventually cost Oasis 500,000 Australian dollars payable to the original songwriters).

A bolstered Noel is now forging a reputation as not only The Chief in Oasis, but as the UK's chief cultural critic, declaring to the *NME* that the prevailing culture is "poncey, serious and everyone's gotta make some sort of statement, whether about *Parklife* or their feminine side or their politics." Not so Oasis. "We're a rock 'n' roll band," he declares, "we say all you need is cigarettes and alcohol. Don't analyze our band. 'That's a good song, that is.' What does it mean? 'Who gives a fuck what it means!' And I don't think anyone's ever sung about plasticine and Coca-Cola in the same song ["Shakermaker"]. It's just a feeling. Get it in the charts!"

New York, July 1994. On their maiden New York voyage Oasis meet legendary lensman Mister Tom Sheehan for the very first time, here to document both their blistering, 500-capacity Wetlands show and the video for third single, "Live Forever" (on its way to No. 8). These images will become iconic, scenes of a band at the most exciting time for any band who are not only on the way up, but rocketing towards the epicentre of youth culture itself: out on the town, under transatlantic flags, Noel on a payphone, Liam with a bewildered cop, larks with Liam in a wheelchair, the glorious gig, Liam "reading" a book in bed (1994 drug trade polemic *Cocaine True, Cocaine Blue* by Eugene Richards), the band at the Strawberry Fields' Imagine mosaic in Central Park. It's a compelling portrait of the young Oasis: carefree, invincible, swaggering through life. No wonder: *Definitely Maybe* is imminent.

After several false starts and changing producers (the right man, Owen Morris, was finally found via Noel's new pal and teenage hero, Johnny Marr of The Smiths), *Definitely Maybe* is released on 29 August, becoming both No. 1 and the fastest-selling debut album in UK history. Every song will become a classic, featuring a succession of synapse-bustin' one-liners delivered in Liam's immediately iconic vocal, both belligerently punk rock and searingly emotive. What he does with one word, on "Cigarettes & Alcohol", defines his insurrectionary attitude: "…imagin-aaay-sheeeuuun…". It's a cultural event so momentous even its reviews become famous. "It's like opening your bedroom curtains one morning," declares the *NME*'s Keith Cameron, "and discovering that some fucker's built the Taj Mahal in your back garden and then filled it with your favourite flavour of Angel Delight. Yeah, that good."

For millions of us it was love at first listen, finding in its pulverizing energy and fearless yearning a profound, giddy connection. For me, these weren't songs written for men, as history would go on to suggest, these were songs written for romantics, for daydream believers, for ordinary young people from ordinary towns willing themselves into a bigger,

brighter reality, maybe even a thrilling lifelong adventure. Young people just like me. Those touchstones that formed Oasis – romance, escape, belonging – were now the touchstones of Oasis fandom. "Oasis," Noel will tell me many years later, "is a celebration of the euphoria of life."

Euphoric celebration is one way to describe Oasis' inaugural year at pop's epicentre, a rapidly accelerating 12 months lived through a blizzard of cocaine, sold-out tours and eye-boggling magazine cover stories. The chaos is relentless: interviews descend into booze-berserk bedlam, they're thrown off a ferry to Amsterdam for a drunken punch-up with Chelsea fans, Bonehead is anointed chief hotel-room-wrecker, they harangue East 17 so badly one night that the Walthamstow pop lads leg it out of their shared hotel, motorized golf carts are stolen at Gleneagles, fans are smuggled into hotels, Noel prangs his guitar off a fist-swinging punter's head in Newcastle, they're thrown out of Sweden for causing £30,000 of hotel room damage (as are their trashing buddies Primal Scream and The Verve), hotel phones are tossed from windows, they're banned from four UK hotel chains and from their favourite London hotel, The Columbia, after a table is flung from a window and shatters the windscreen of the hotel manager's Mercedes. On they revel, as arms flail, bottles fly and chairs sail overhead, landing in hotel swimming pools at dawn. They might as well be gift-wrapped in tinsel and sent straight to the news desks of the music press and tabloids, both gleefully receiving this once-in-a-lifetime, cartoon, rock 'n' roll cavalcade. Moving from town to city, squeezed together in a Transit van, they feel, as Bonehead has it, "like a bunch of fucking Vikings, invading England for the first time." And the public, everywhere, adores it.

"We were the best soap on TV at that time," nods Liam. "I wouldn't change it, man. When you've got the press outside your door and they're making shit up and you've gotta explain it to everyone, that does my head in. But the rest of it's funny. When you're 21 and you're the biggest – well, I prefer the *best* band in the world – it's your right to be

doing shit like that. You don't join a band to turn into fuckin' monks. It's not in my make-up, man. I don't mind being a cartoon. As long as it's a good one."

September 1994. Oasis are back in America and this time there's *too much* celebrating of the euphoria of life. With no break for over a year, touring through mainland Europe and distant Japan, they're now in LA's Whisky a Go Go, taking the hardest drugs imaginable, by accident, as Noel recalls in the 2016 documentary *Supersonic*. "Someone had discovered the joys of crystal meth," he balks, "which is effectively like ninja speed." "And we all thought it was coke," adds Liam. "We were doing big fuckin' lines of it." Bedlam ensues. Clattering onto the Whisky stage, they've all been up for days already, a roadie accidentally hands Noel the wrong setlist, the band members play different songs at exactly the same time, Liam snorts crystal meth off an amp and throws his tambourine at a wasted Noel's head. Appalled, Noel pulls the next nine shows, has a ferocious bust up with Liam and disappears to San Francisco with $8,000 of the band's touring float. There, a girl befriends him and saves him, as he tells us on the song that then emerges, the beautiful, tender "Talk Tonight" (B-side of "Some Might Say").

Missing in action, he's eventually found in Las Vegas, gambling, where he's persuaded by Creation co-founder Tim Abbot to rejoin the band in Texas. Another two singles follow, "Cigarettes & Alcohol" (No. 7) and the standalone Christmas No. 1 contender "Whatever", a No. 3 hit fairly beaten to No.1 by the sumptuous "Stay Another Day", a fitting vengeance for the East 17 lads they sorely tormented. By the end of the year Oasis are both the biggest *and* best band in Britain.

"It's a dream, really, isn't it?" Noel tells Ireland's *Hot Press* that year. "You dream of being on *Top Of The Pops*, you dream of being in the back of posh cars, of not having to pay for anything, of loose women, and all the rest of it. That's all come true, so you might as well enjoy it while you can, before it finishes. You're only going to get five years out of all this."

# NEW YORK CITY:

This was my first encounter with the band, a trip to New York shortly before *Definitely Maybe* was released.

On the flight over the band were up front, with the *Melody Maker* journo and me stuck at the back with the goats and chickens. Liam came back to our section just to say hi. I'd met Noel very briefly before, but this was my first brush with Liam. I'd been told even at this early stage that the band were a lairy lot. I'm not intimidated by lairy, so I was looking forward to it, but I was also curious about these roughnecks I'd heard about, ready to cause trouble. But that wasn't the case at all. Liam was a really nice chap, interested in what we were doing and what we had planned on the trip.

It was a similar story once we'd got to New York. I remember heading to the hotel bar to meet the band for a drink. Liam had arrived first and while he waited for everyone I spotted him chatting away with an old fella who happened to be in the same spot. It was

such a sweet, endearing moment for someone who I'd been told was a nutcase, but here he was, happily shooting the breeze with a complete stranger, no airs and graces. I thought, "We're gonna get on like a house on fire." The rock 'n' roller in him did appear before long, of course – the bar filled up and I remember their manager Marcus picking up a tasty bill at the end of it.

When it came to shooting, I tramped them all over the place, all the tourist sites. Greenwich Village, Strawberry Fields, the Dakota building – you name it. We even went to the Oasis Community Garden where they filmed a promo video. At some point we were heading back to the hotel and stuck in gridlocked traffic in Times Square when Liam jumped out, saying he wanted to get himself a T-shirt. I followed him out and he ended up getting the New York top he's wearing in some of the shots, John Lennon-style. Within seconds of getting out the sky turned black and it started sheeting down,

# 1994

golf-ball-sized drops of rain. As we were running through the ensuing bedlam I shouted, "Over your shoulder!" at Liam and rattled off a few frames. It's one of my absolute favourite shots of the band. He's in this crowded place but completely on his own. No one knows who he is yet – the fame, the fans, the crowds, that's all still to come.

Oasis played the Wetlands one night, and they were blistering. This was their first time in the US and they were setting out their manifesto, they wanted to leave them all for dead.

Not long before we went our separate ways, I told Liam that there was this great book in the hotel bookshop, an expensive arty one called *Cocaine True, Cocaine Blue*. I thought it would make for a fun, stupid, maybe slightly crass shot to have him read it. He was up for it, so Liam, Noel and I popped back up to a room and I took some shots. Not long after, their PR guy asked me if I could try not to use them too widely, as all of the hellraising stories were really starting

to do the rounds, and these photos would just fuel the fire. So they were under wraps for a while, but time has passed and the context is very different, so here they are again.

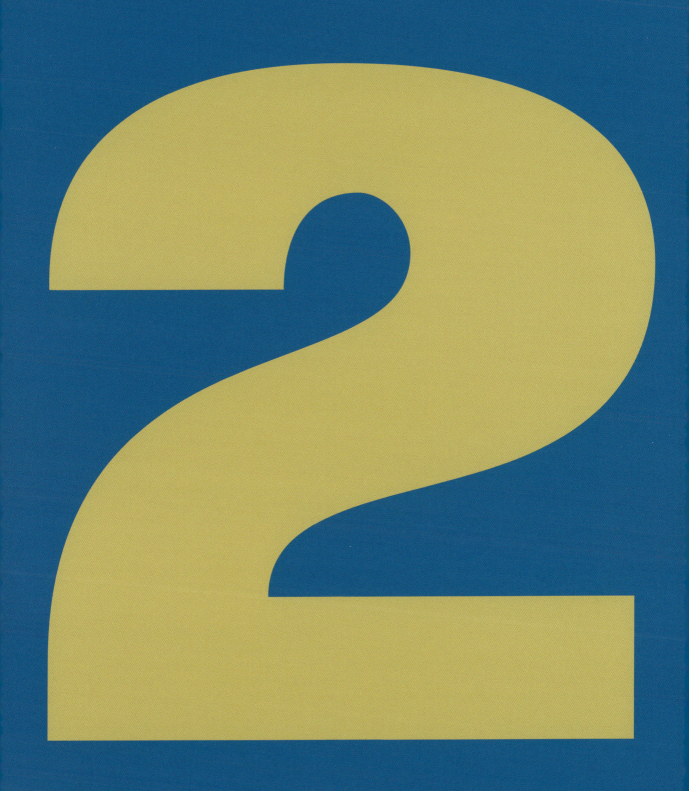

# ALL YOUR DREAMS ARE MADE

The Brit Awards, February 1995. "And the winners for the Best Newcomers . . . truly wonderful . . . Oasis!" So announces the visibly chuffed Kinks legend Ray Davies, an all-time hero of Blur's Damon Albarn, as Oasis pick up their first-ever Brit Award (officially for British Breakthrough Act). The night, however, is dominated by Blur, who win four Brit Awards (Band, Album, Single and Video, all for *Parklife*). This public approval from a songwriting master isn't needed to fuel the already raging deadly rivalry that exists between the swaggering northerners and the cocky southerners, but from this night onwards it's an ever-blazing cultural bonfire continuously stoked by the fiery coals of the cackling British music press.

This month Oasis are also in Wales, recording "Some Might Say" (destined to become their first No. 1 single) alongside two of their soon-to-be-celebrated B-sides, "Talk Tonight" and "Acquiesce". Owen Morris is already here in Locomotive Studios producing The Verve's mighty *A Northern Soul*, Noel helping himself to the Wigan wizards' instruments while Liam provides the handclaps to their haunting single "History".

It's here where Tom Sheehan meets Oasis again, the dyslexic Noel finishing up his lyrics with paper and pen, left-handed. Oasis are now internationally enormous, courted by the stars: backstage they've been visited by tennis ace John McEnroe (who Liam calls "a mad bastard"), Duran Duran's Simon Le Bon ("freaky"), while U2's Adam Clayton sends them a cactus ("an Oasis desert fuckin' cactus").

Through early '95 they're constantly on tour; the days, locations and incidents now blurring into a montage of international drama. In a bar in Paris, argy-bargy between Liam and Tony McCarroll veers into a punch-up, manager Marcus Russell then sacks McCarroll after Noel declares he's not good enough. Noel's certain he doesn't have the sticksman skills for this stunning new song he's written, "Wonderwall", his homage to girlfriend Meg Matthews. (McCarroll will go on to sue Oasis for £18 million in unpaid future royalties, eventually settling for a reported £550,000.) By May they've a new drummer, Alan White (brother of

Steve, who drums for Paul Weller), and recording for the second album, provisionally titled *Morning Glory*, begins in "earnest".

Rockfield Studios, on the Welsh borders, is the mythical, residential retreat where Queen part-recorded "Bohemian Rhapsody" in 1975 and where, twenty years on, Oasis are recording *Morning Glory* in an astonishingly speedy two to three weeks. That this will become a seismic recording in rock 'n' roll history is made all the more miraculous by its unfolding, midpoint events. One night, at five in the morning, with six tracks already completed, Noel strides into the studio and what he calls "half of Monmouth" is already there, playing with his expensive guitars (one of which is a gift from The Who's Pete Townshend). Liam and Bonehead have invited a boozed-up coterie of "mates" back from the pub and a riot ensues: Noel attacks Liam with a cricket bat, air rifles appear, Liam throws a hefty bunch of keys at Noel, who then locks himself in his bedroom, Liam attempts to kick the door in and as dawn breaks there are 13 smashed windows in the legendary countryside idyll. As Owen Morris describes it: "They were killing each other. Literally wanting to kill each other. Noel said he wasn't coming back and that was it. End of band." Tempers cool, the band reforms and (*What's The Story) Morning Glory?* emerges, featuring four enormous hit singles – the jubilant "Some Might Say", the thundering "Roll With It", the deathless "Don't Look Back In Anger" and the sublimely atmospheric "Wonderwall". The latter, Liam originally declares, is "shit", describing it as both "reggae" and "trip-hop", until he agrees to sing it, when it suddenly becomes, as Noel recalls, "the greatest song ever written."

Talking to Liam about the fabled Rockfield fracas, he tells me in the days afterwards that he visited Peggy back in Burnage, with his leg in a cast, an air rifle dangling down his back and cricket-bat injuries all over his body. He meticulously impersonates the profoundly Irish Peggy opening her front door and exclaiming out loud – "What kind of fockin' record are yer makin' up there!?"

# 1995–1996

Early June, and Tom Sheehan meets Oasis once more for a live show at the Bath Pavilion, a warm-up for their inaugural Glastonbury headline set. The show is rollicking, the sound BIG, the band premiering "Hello", "Roll With It" and the carousing "Morning Glory". The performance also features an appearance from then-wayward Oasis gatecrasher Robbie Williams during "Shakermaker", despite being described by Noel as "the fat dancer from Take That".

By mid-August, the Blur/Oasis deadly rivalry is reaching its apex, both releasing singles simultaneously – "Roll With It" and "Country House", and both vying for No. 1, with the *NME*'s coverlines gleefully anointing this landmark historical event "The British Heavyweight Championship". Over on Channel 4's *The Big Breakfast*, as a nation foams with excitement over "The Battle of Britpop", supermodels Kate Moss and Naomi Campbell publicly choose their side, lustily sashaying to "Roll With It". Blur, nonetheless, win the No. 1 battle. But the war is yet to be won.

Virgin Megastore, Oxford Street, October 1995. The anticipation is crackling. Around a hundred expectant punters, guests, music journalists and photographers are jostling in front of a makeshift stage as a song that no one knows peals overhead, asking an intriguing question: Where were you while we were getting high? Suddenly, there's a flash of cream overcoat as Liam bowls onto the tiny stage, rubbing his nose, with Alan White following behind, as the crowd whoop and whistle. "I'm off me tits, yeah, can't remember the words," he announces into a mic, as Noel strides on stage clutching his acoustic guitar, sits on a stool and takes charge. "Evening! Or morning…" he declares and begins singing "Yellow Submarine", which inspires Liam to launch into a skewed-up cockernee blast of "Country House", "…a very big cuntery!" A brotherly exchange brings up the words "Live Forever" and so, tonight, in this official "live acoustic set" to promote the release of *(What's The Story) Morning Glory?*, Liam blasts into the famed single from *Definitely Maybe*, his voice stripped bare. "Where's the bass, man!?" he announces mid-song, seemingly unaware there's no Guigsy in sight. "I truly have lost the plot,

big time, man . . . doing one more song and I'm out of 'ere!" Now he starts singing "Live Forever" all over again, vocals disintegrating altogether, which he ends midway with the word "sausages!". He bowls off stage, disappears through a door and Noel takes charge once more. "Alright, this song's called 'Wonderwall'…" he announces and sings, beautifully and tenderly, the song his brother is supposed to sing but cannot remember the words to. Then he sings another song that his brother is supposed to sing but cannot remember the words to, "Cast No Shadow". As the crowd hollers and cheers, the message from Noel has been clear: *this* is what it's all about.

*(What's The Story) Morning Glory?* is released on 2 October 1995 and sells 342,000 copies in its first week, with CDs flying out of mainstream record stores like frisbees hurled in a frenzy, spending the next ten weeks at No. 1. It will eventually sell 22 million copies worldwide. Where Oasis pulse at the heart of the mainstream, redefining what a No. 1 pop star can be, the wider culture now aligns in accordance with an unstoppable DIY spirit, a spectrum of classic albums released through '95 and '96 alone, beyond Oasis and Blur, defined by an outsider, maverick mindset. Era-defining works emerge across the genres, from Pulp, Portishead, Massive Attack, The Prodigy, Supergrass, Elastica, The Chemical Brothers, Tricky, Radiohead, Black Grape, The Charlatans and Manic Street Preachers. This also means, naturally, boomtime for the also-rans, from Shed Seven to Sleeper to Northern Uproar to Cast, to the micro phenomenon of Camden's posturing Menswear.

"I tell you what I found funny the other day, me and Our Kid pissed ourselves laughing," Noel tells *Select*. "We opened the press to find out that poor Johnny and poor Simon from Menswear have had nervous breakdowns because, being Johnny and Simon from Menswear, the press had all become too much. Like, you wanna try being me and this cunt (Liam) for an afternoon. You'd slit your own fuckin' throat, mate! No wonder we've got a 40-grand-a-week crack habit, as it says in the *News Of The* fuckin' *World*. The pressure of being Menswear? Nobody knowing who you are, playing to two people down in Camden. *Pressure*."

February 1996 and Oasis are No. 1 again with "Don't Look Back In Anger". They're now *always* No. 1, except for last November's "Wonderwall", held off at No. 2 and robbed of its rightful position by two pretend soldiers on the karaoke, Robson & Jerome, with the woefully weedy "I Believe". Liam is now the nation's favourite insubordinate surrealist, threatening to play "golf off George Harrison's head", who addresses a narcotic-questioning policeman with, "What's it got to do with you, cuntybollocks?" At this year's Brit Awards, Oasis avenge Blur's '95 cache by winning Best British Album, Best British Video and Best British Group, where an antagonistic Noel "quips" to presenting INXS frontman Michael Hutchence, "has-beens shouldn't be presenting awards to gonna-bes." Liam, during a frenzied thanking list (and sporting an itinerant madman's beard) bursts into a rendition of "Parklife", ending with "shite life!" His life is anything but: he's now stepping out with glamorous acting/singing star Patsy Kensit.

April 1996. Tom Sheehan is with Oasis once more, in Canada, for a shoot celebrating *Melody Maker*'s 70th anniversary, where all five members nominate the greatest music in history on the palms of outstretched hands. Liam goes for *The Beatles 1962–1966*, Noel with *The Beatles 1967–1970*, Alan with Small Faces' *Ogdens' Nut Gone Flake*, Bonehead with Bob Dylan's *Highway 61 Revisited* and Guigsy (being the band's champion stoner) with Bob Marley's *Uprising*. Two months later, Oasis play the biggest shows of their lives; two nights at their childhood theatre of dreams, the one with the twinkling, silvery floodlights they could see across the rooftops as daydreaming, glitter-eyed kids.

Maine Road stadium, Manchester, 27 April 1996. At 2.15 p.m. touts are selling tickets for a wallet-melting £300 cash, and outside a nearby boozer beer-clutching fans are bawling all the words to "Digsy's Dinner", ecstatic young people who could well be having the best day of their lives. I'm here with the *NME*, and my task is to review not the gig but the crowd and hear a fabulous rumour: during soundcheck Oasis were rehearsing the theme tune to the classic cartoon caper *Scooby-Doo: Where Are You!* This inspires a table of exuberant

22-year-olds calling themselves The Euston Posse to loudly impersonate Liam. "Scooobeee doo-beee doooo-weh! Wey-rahr-yoooo-weh!" Mike from the Posse proffers a ready-rolled spliff, "prison fag, anyone?" and wonders aloud, "Would you like to see our drugs setlist?" On a crumpled piece of paper I'm seeing a work of forensic precision, neatly drawn vertical columns next to each Posse member's name detailing the revelling to come: "Pills", "Bag", "Skunk". "It's just like a big holiday," beams Mike. "They're just that brilliant that they've taken over the world, simple as that."

Inside the stadium we're 50,000 strong, aged 5 to 50, mostly twenty-somethings in crisp, labelled sportswear and merchandising T-shirts in a Maine Road that resembles a vast Oasis theme park. It's sixteen deep at the bars by the "food" stalls (crisps, chocolate, chips, sausage rolls) while punters shimmer their brought-in tambourines and an eight-year-old boy tells me his favourite Oasis tune ever, "Married With Children", singing his favourite line: "yer music's shite … he he heh!" Up on stage, the band stroll on to a roar so gigantic we're elevated into the air, where we stay for 90 minutes, blaring out those glorious communal anthems, together, like we truly *will* live forever.

After the first of those Maine Road shows, Liam returns to Burnage, back to the bedroom he shared with Noel, where the dreaming first began. "I was still living at me mam's that day, first gig," he tells me. "Come back home, sitting on me bed. That same bed. 'Fucking hell, man, just played that gig, insane.' The next day, I moved in with Patsy [Kensit]. Moved out of me mam's house into a fucking million-pound house in St. John's Wood. *That* was good. I haven't been back since. Why would you go back *there,* man? *Fuck that.*"

Sometime in the early 2000s I present Noel with a selection of classic photos to caption for a special edition of *NME*. He's given the most iconic Maine Road image of them all, Jill Furmanovsky's shot from the back of the stage, Noel standing on the lip, facing the enormous crowd, both arms straight out to the side. "Helicopters overhead and everything, proper

mega, it was like Vietnam," he declares, still awestruck. He picks up a marker pen and writes a typical, infinitely ambitious caption: "I Am The Cosmos."

Everything, now, is BIG. Noel and his fiancé Meg are living in a multi storey townhouse he names Supernova Heights, in North London's Primrose Hill, which operates a party-hard open-door policy. Much like Liam in St. John's Wood, after all those threadbare years, he's fully embraced Living The Dream. "I invited a full awards ceremony back to mine once," he tells the *Guardian*. "George Best included. I gave out my address and said, 'Everybody back to mine.' And loads came. It was a great day. The police were called and all sorts." He also owns the chocolate-brown Rolls-Royce that Alan McGee gave him, post-*Morning Glory* success, which he'll never learn to drive.

In May, Noel and Meg visit the exclusive Caribbean island of Mustique, staying at Mick Jagger and Jerry Hall's residence alongside Johnny Depp and Kate Moss. For the ever-diligent Noel this is a "working" holiday, honing the demos for third album *Be Here Now* on a digital 8-track and a keyboard (after two weeks, producer Owen Morris joins him). Early that August, Oasis play two enormous Scottish shows at Balloch Castle Country Park, Loch Lomond, to 80,000 fans, the biggest concerts of the decade for Scotland. Then, one week later, the concept of BIG becomes GIGANTIC.

Tom Sheehan is there for the Knebworth concerts' press call, snapping Oasis in front of enormous speakers emblazoned with a milky swirl that will carry the blasting soundwaves across the roaring heads of 125,000 people, for two nights in a row, on 10 and 11 August 1996. They could've sold out *twenty nights*: 2.6 million people apply in the biggest demand for concert tickets in UK history at the time.

We freeloading journalists are not only spoiled at Knebworth, we're outrageously encouraged: there are 7,000 names on the guest list, the huge backstage area is a purpose-built revellers' village, featuring pristine white-linen marquees named Gin Bar and Champagne Bar, which are infinitely stocked. For those

who wish to eat (no one), posh meats sizzle on barbeques while trick-playing magicians roam for our entertainment. It's lavish, excessive, preposterous, and all of it is *completely free*. All night. Swaying out into the vastness of the crowd, 125,000 people are once more elevated into the air, singing those irresistible anthems as Noel stands on the lip of the stage, pointing into the cheering crowd, making his milestone announcement: "This is HISTORY."

The Oasis cultural balloon is now blowing up into the size of a Zeppelin. As an MTV *Unplugged* performance approaches, an argy-bargy erupts over Liam's lack of enthusiasm for a forthcoming American tour and, in protest, on the *Unplugged* night itself, Liam bails out, citing "throat" problems. The show must go on, with Noel and his acoustic guitar. Liam, perhaps not resting his throat as much as any doctor would've ordered, sits in the balcony with his now fiancée Patsy, heckling, drinking and smoking. A week later, as the band prepare to leave for America, he storms away from Heathrow Airport declaring he's going house-hunting instead. The show goes on, as ever, in America, without him. Eventually, he turns up for a handful of shows, attends the MTV awards at New York's Radio City Music Hall and causes consternation in a starry audience including Neil Young, Smashing Pumpkins, Alanis Morissette, Metallica, LL Cool J and Beck. Up on stage, through a raucous "Champagne Supernova", he goads Noel with obscene gestures, spits beer across the stage, smokes a snout, delivers the line "a champagne supernova up your bum", slams his mic on the ground, storms off stage and leaves the band to finish the song without him. A Gallagher brothers' punch-up inevitably ensues, the remainder of the American tour duly cancelled. Peak debauchery, it seems, has been reached.

But there are other peaks still to scale: work has only just begun on *Be Here Now*, early recordings at both west London's Abbey Road and Surrey's Ridge Farm Studio. The tracks sound, as Alan McGee describes them, "fucking loud", while Noel's stated sonic intention is captured in a single word: "COLOSSAL."

# LOCOMOTIVE STUDIOS:

We'd got on really well on the New York trip, so the feeling was that my second encounter with the band – a trip to rural South Wales where the band were recording songs that would appear on *(What's The Story) Morning Glory?* – would go nice and smoothly. Problem was, on arrival it became clear that Tony, Guigsy and Bonehead were about to go away for the weekend, so I had about 30 minutes to grab some group shots with the whole ensemble before they knobbed off.

We jumped into action and took some frames around the studio. It was well-known by this point that the band, Liam and Noel especially, were Beatles obsessives, so I thought it would be a really nice visual to get them on the roof of the studio to mimic the famous poses from the *Help!* album cover. The chaps were obliging and started to climb up a ladder. The only problem is that Guigsy, just like me, doesn't have a head for heights. He was shaking like a leaf but, God bless him, you wouldn't know to look at the shot. It

took him about 10 minutes to get up the ladder and 15 to get back down again, geed on a bit by the rest of the band. But he was a trooper that day, to do something he wasn't comfortable with in order to get the shot.

After that initial burst of action there was a nice, relaxed vibe to the rest of the weekend. We'd sit around the table at the studio for ages, just talking, drinking, eating, watching telly. The kind of evening that just disappears and all of a sudden you're going to bed at three in the morning.

Over the course of the weekend we went out and about on a few trips, but we also spent plenty of time in the studio, where Liam and Noel were working on "Some Might Say", which ended up being their first No. 1 single. I did some shots of the folks there singing backing vocals, gathered round a mic. At one point it was all hands on deck to do some group clapping, so I like to think my claps are on the track, but who knows, maybe they called the professionals

# 1995

in later. Both Liam and Noel were pretty serious when it came to recording – they knew what they were there to do. I guess Noel had some experience of this world thanks to his time as a roadie with Inspiral Carpets, but for Liam it was all new, he was just working on self-belief.

On the Sunday morning Noel and I were up fairly early, so I rattled off some frames with him in the studio. We'd popped into Newport the day before and he'd picked up a Parka at the market which he was quite proud of. I love the shot where he has the hood up over his eyes. It was a risky shot at the time, because although the band were a massive success they probably hadn't quite reached that icon stage, where you'd recognize Noel with half of his face covered up. He was working on his lyrics and at one point I said, "Give the old thoughtful writing pose," just a bit of fun. It was that kind of vibe.

On the Sunday afternoon we drove to the nearest pub, which was in a hotel. It was in the days of early closing, so the pub closed later that afternoon and tried to kick us out. I went to the bar and argued our case, that this was really a hotel, not a pub, so surely we're just hotel guests who happen not to be staying the night? It wasn't the strongest defence, but I managed to get us another drink, which went down well.

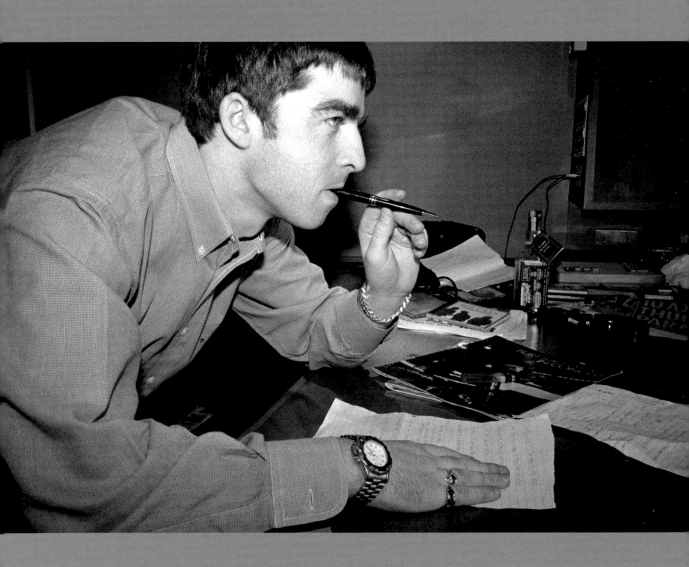

A.            turned down (fade u

Verse        A ——▷ F# G
BRIDGE       A  G  F# F E
CHORUS       F  C  G
BRIDGE       A  G  F# F  E
VERSE        A ——▷   F# G
BRIDGE       A G F# F E.
CHORUS       F  C G
to END (F E A ? C G (D strings)

# BATH:

I met up with the band again that summer, to see them play
a show at Bath Pavilion. It was a warm-up show before
they headlined Glastonbury the very next night – this
time playing to a crowd of about 1,000 people rather than
80,000-odd at the festival.

Once again, they delivered 120 per cent. You can see in
the shots that Liam is soaked in sweat. The whole place
was dripping, it was great. The band were already massive
by this point so there was a real buzz. The second album
wasn't quite out yet, and they gave a few of the new songs –
"Roll With It", "Morning Glory", "The Swap Song" – their first
ever public outing.

# 1995

# PHILADELPHIA:

This encounter was on the hoof, a bit undercover, if you will. Oasis were on a big world tour for the second album well into 1996. At this point they were the biggest band on the planet, and as a weekly music mag we at *Melody Maker* had to cover them pretty regularly. So Jonesy (Allan Jones, the *MM* editor) sent me and a journo Ben Marshall out to intercept them on tour. We hadn't lined anything up with them in advance, we were free agents, just trying our luck, really.

They were playing at the Tower Theater in Philadelphia, the venue where David Bowie had recorded a live album twenty-odd years earlier. We arrived in town a few hours ahead of the gig and thought, let's go along to the soundcheck and see what we can find. We walked through the stage door and I bumped into Jason Rhodes, Noel's long-serving guitar tech. He looked a bit surprised, shouting "Tommy! What are you doing here? The boys are at the hotel." He gave us the name of the hotel, so we headed over there, but we realized that we didn't know what alias

they were booked under. The oldest trick in the book! I tried asking for the Gallagher brothers, but no joy. So we headed back to the venue.

By this time, things were livening up. The barriers were up, security were about, so it was hard to get into the show, let alone meet up with the band. We put on our best English accents and talked up our press credentials to security, the usual bullshit, but they weren't having any of it. Then right at the end of the alley next to the venue I happened to spot Liam, who'd popped out for a smoke or something. I called his name a few times but no good, he couldn't hear me – so I let out a barrage of expletives at him, and that got his attention. "Fucking hell, Sheehan! What you doing? Come on through!"

They were finishing up soundcheck at this point, but Noel wasn't needed, so we popped across the road to a bar, where Ben started to interview Noel and I got some nice

# 1996

shots. We headed over to the venue for the show, then went backstage afterwards. There's a shot of Liam doing his best James Bond impression and kissing a lady's hand, smooth as an alligator's best coat.

I think when a band is on tour in some foreign land they're happy just to see a familiar face, someone they know a bit, who they can talk to and relax with. So, in the end, a bit of luck, plus my friendly and – a few choice words aside – respectful relationship with the band had paid off, and we had got in and got the material we wanted for the paper, with a shot of Noel in that bar ending up on the cover.

# VANCOUVER:

We went through the usual official channels for this shoot, just a month or so after our under-the-radar trip to Philadelphia. *Melody Maker* was celebrating its 70th glorious year, and it made perfect sense for us to shoot the biggest band in the world for the anniversary cover. It helped with me having a friendly, professional relationship with the band – they knew what they were getting, and that I'd be economical with their time.

Oasis were playing the Coliseum in Vancouver, and I had some time with them beforehand. The idea we'd had was to get them to celebrate their favourite albums. I'd been very organized and printed out little forms for them to fill in with some of their most-loved albums, songs, films, etc., which made for interesting reading. I still have them tucked away somewhere.

Then I bought a set of paint and brushes, and I got them to paint the titles of their favourite albums on each others' hands. It was just a silly visual shorthand, the kind of thing photographers like to use sometimes to get a point across and create a nice image. It made for a nice cover, a wraparound with Liam and Noel on the front and the rest of the band on the back of the magazine.

I went along to shoot the show that night, which was an interesting one. Liam stormed off stage a few songs in after someone threw a shoe at him, and that was that.

**1996**

# KNEBWORTH:

A crowning moment for the band. I was at the massive Knebworth concerts mainly to photograph The Charlatans, who were playing support on the Sunday night, so I didn't spend much time shooting Oasis – someone else was covering it for *Melody Maker*. Which did mean I got to watch some of the gig at least.

My involvement with the band themselves was limited to the press call that took place a few days before. You always know these things are going to be crap, I hate doing them. There were dozens of us photographers lined up behind a barrier like rabid dogs, snapping away as the band walked up the hill towards us. We were all getting the same shots, but it was such a massive moment for the band that we had to cover it.

It wasn't really a session, more of a bun fight, and it started off as predicted, all pretty static. But I shouted out, "Fucking hell, chaps, you're too spread out! Stop being lame, get something going!" I didn't mind being a bit cheeky, they'd have known I meant well.

To be fair, that got them going and they got into a bit of a bundle at the end. Finally, some interesting shots! Instigated by yours truly, but of course every bugger behind the barrier got the shot.

**1996**

# CAUGHT BENEATH THE LANDSLIDE

It's 1997. While everything Oasis records sounds BIG, so is everything they *do* and everything they *say*, with the Gallagher brothers permanently plastered in every way across the tabloid newspapers in the era where the *Sun*'s Bizarre pop column is generating front-page news.

"They were crazy times, a lot of drinking," Noel tells *XS Noize*. "You're the biggest band in the world, making this much-anticipated new record, it was the birth of celebrity culture and Britpop had crossed over into the tabloids. I was constantly having a microphone shoved into my face. No way to make a record."

Liam is constant headline news: stalking off stage in Glasgow after someone hits Bonehead with a bottle, pouring drinks over a TV journalist's head for reviewing shamed 70s glam perv Gary Glitter, marrying Patsy Kensit in Marylebone Town Hall (while Noel marries Meg Matthews in Las Vegas two months later). Liam's marriage proves no stabilizing influence. There's a road rage incident, he headbutts a fan in Australia and is banned from Cathay Pacific airlines for life (an argument over a scone). "It wasn't like I just started on anyone," notes Liam in his defence. "But if people wanna fuck with me, I'm gonna fuck with them back. I've only ever stood up for meself."

The *Be Here Now* sessions decamp from a press-intruded Abbey Road to Ridge Farm in rural Surrey, and the press simply follow, the band then returning to London's AIR Studios where the engines on their Zeppelin begin to threaten to blow altogether. Here, multiple guitar overdubs, as heavily featured on "Stand By Me" and "My Big Mouth", are the basis for Noel's COLOSSAL remit, using what he calls "this huge desk the size of Bradford" and *two* tape machines to deal with the multi-multiple tracks. Owen Morris proclaims the final mix "terrible". Noel agrees: "It is *shocking*."

*Be Here Now* is released on 21 August 1997 and sells 424,000 copies in the UK in its first day, a monumental musical folly that becomes the fastest-selling album in UK chart history. Noel will blame the drugs. "It's the sound of a bunch of guys, on coke, in the studio, not giving a fuck," he tells the 2003 documentary *Live Forever: The Rise and Fall of Brit Pop*. "There's no bass to it at all. All the songs are really long, the lyrics are shit, and for every millisecond Liam is not saying a word, there's a fuckin' guitar riff in there in a *Wayne's World* style."

The accompanying tour is equally as preposterous, Noel reflecting in the early noughties on the most chaotic show Oasis ever played, in 1997, somewhere (he thinks) in Holland. "We were stopping songs halfway through and just laughing, we were that bad, a disgrace," he tells me, merrily. "The tour was nine months long and we went fucking mental from the first gig to the last gig, fucking beyond out-of-control shit-faced. We'd started 'Roll With It' going 'Ay, ay, ay! I fuckin' hate that song anyway, man, what's next? *[bawls to imaginary audience]* Does anybody 'ere like "Stand By Me"? Fuck it!' It was proper Dean Martin 'doo-be-dooo'. We came off after the gig, walking through this arena and this big truck's there with a mixing desk in it and I said to Maggie [Oasis' tour manager], 'Don't tell me that was being recorded, cos if it is, don't ever let that gig go out!' And she said, 'It went out *live*.'"

The following year Oasis release *The Masterplan*, their B-sides compilation, the generous songcraft "giveaway" Noel had always admired in the quality B-sides of his forebears The Jam and The Smiths. It's a stunning, masterful collection: from the emotional reach of "Acquiesce" to the delicately brooding "Talk Tonight", from the singalong euphoria of "Listen Up" to the sublime romance of "Going Nowhere", from the transcendental "The Masterplan" to the gorgeous yearning of "Half The World Away" (later adopted as the theme tune to the much-loved sitcom *The Royle Family*).

"From '93 to '96 every song I wrote was a classic. I thought it'd last forever," Noel announces, unapologetically, to Mr Hyde. "If *The Masterplan* had come out instead of *Be Here Now*, we may have won the Nobel Peace Prize. I don't think there'd be war in the Middle East. I think we'd have saved the world, the songs were that good." *If only.*

# 1997–2001

The year 1998 is when Noel declares taking drugs, for the majority, is like "a cup of tea in the morning". That same year, while watching the World Cup, Noel has a panic attack, now a regular occurrence, and a doctor spells it out: the drugs must go. Noel does what he's told, goes to bed for two days and toughs it out, alone.

"The only two people out of our circle of friends in the 1990s who've never been in rehab," Noel tells me in Wheeler End studios, Buckinghamshire, in 2006, "are me and Liam. Out of all those hardcore drug-takers and drinkers. I feel quite proud about that."

He's been used to struggling through crises alone, he adds – "Oasis is all *about* the struggle" – before a rueful observation. "Once you've been left unconscious on the floor by your dad and you know you're not gonna die, then you've no fear of anything," he muses, matter-of-factly. "I don't need to sit in a darkened room and pay some geezer four grand an hour to tell me things I already know about myself. 'So, let's go waaaaay back to your childhood.' Er, no, actually I wouldn't mind stopping taking drugs. Forget my dad, it's nothing to do with my dad, how do I just *stop?* People get swept up with being in London and talk a lot of fanny."

In 1999 both personnel and circumstances are changing. During early recordings of fourth album *Standing On The Shoulder of Giants*, Bonehead leaves, as does Guigsy weeks later, so two new musicians are then swiftly recruited in Heavy Stereo vocalist/guitarist Colin "Gem" Archer and former Ride/Hurricane number one guitarist Andy Bell on bass. Tom Sheehan is with them once more, shooting the new, significantly refreshed and agreeably Mod-ish line-up for *Uncut* magazine.

The Gallaghers, meanwhile, become dads: Liam and Patsy welcome son Lennon on 13 September 1999, while Noel and Meg welcome daughter Anaïs on 27 January 2000. By now, Alan McGee has closed Creation Records, and Oasis are ringing in the millennium with their own label, Big

Brother Recordings, on which they release the woozy "Go Let It Out", yet another No. 1. *Standing On The Shoulder…* also becomes No. 1, despite Noel's subsequent confession that he was void of inspiration, and the album was an excuse "to go on tour", hastily created "in a haze of coming off drugs, downers and alcohol."

That May, after a show in Barcelona is cancelled, the band embark on a bender, culminating in a brawl: Noel jumps Liam and splits his lip, Liam questions the legitimacy of Noel's daughter and Noel temporarily leaves the band, again. Weeks later, both Liam and Noel's marriages are over. On 22 July 2000 the marital fallout alongside catastrophic drinking causes their most infamous gig yet, at Wembley Stadium, where an alarmingly wayward Liam constantly swears, skews the lyrics, calls Wembley a "shithole", needles Noel, requests bare breasts to appear on the stage screen and calls Patsy a "bitch" who's left him without "a tea bag". The show, announces an aggrieved Noel, is Oasis' official career "low point".

Mercifully, new love blooms for both the brothers, who are soon in stable long-term relationships – Noel with PR executive Sara MacDonald, Liam with former All Saint Nicole Appleton, with whom he welcomes their son, Gene, in summer 2001. Within weeks, a street-lurking photographer attempts to take a babe-in-arms family picture and is punched in the face by Liam.

The culture, meanwhile, is now unrecognizable: the dynamic, carefree chaos of the maverick 1990s has morphed into a shiny world of entertainment dominated by teen pop, celebrity culture, talent shows, reality TV, media-trained non-personalities, an aggressively corporate, bean-counting mentality and bands-as-brands. And then, geopolitical horror turns up.

It's 11 a.m., 12 September 2001. Noel Gallagher is pacing around a photo studio in North London in a state of heightened emotion. He's been up all night, he despairs, "watching people falling out the fuckin' sky . . . well, it's the end of the world innit?" On this very morning, the day after humankind watched

two hijacked planes crash into New York's Twin Towers and incinerate almost 3,000 people, my journalistic task has been rendered pointless: to interrogate the Gallagher brothers, in a rare joint interview, on the folly of *Be Here Now* and other cultural concerns of zero consequence after this brutalizing day in human history. I give it a go, nonetheless.

You broke my heart with *Be Here Now*.

Noel: "Well, I don't know what people expected."

Some more brilliance, of course.

Noel: "Well, I apologize. That was my fault."

I listened to that album pissed, stoned, tried it in the morning, in the night, on a hill, trying to find the soul.

Noel: "You should've tried it on nine grams of Charlie, cos that's what it was written on."

Liam: "Eheheheh!"

Noel: "Well, everybody has a shit period and hopefully we've had ours. And this new album [forthcoming fifth album *Heathen Chemistry*] . . . is fucking mega! I'm not a drug addict anymore. So it's not just 'fuck it, that'll do', which is what *Be Here Now* should've been called."

Soon, the pace begins accelerating, Noel leading an increasingly spirited condemnation of everything in contemporary culture (apart from The Strokes, who have "the tunes, man"): scorching derision for the rise of Coldplay (Liam declares them "Christian Rock"), the new cultural obsession with fame and celebrity in the era of Westlife, Britney Spears and Steps ("the pop lot," declares Liam, "their goal in life is to have their picture took"), while corporatism and monetary greed had ruined both music and their beloved football.

"Footballers are *groomed* now, aren't they?" withers Noel. "David Beckham went into media training for three weeks before he went on *Parkinson*. Trainin' for what? Just answer the fuckin' question! Football is the same as music, it's not just a business, it's now a *system*. And they're put in the system by people to perpetuate the system, otherwise it's 'We'll send you back to the gutter.' The Man has taken over the world! He [Liam] should be given a knighthood. A knighthood! You couldn't imagine Chris Martin from Coldplay laying out a photographer for takin' a picture of his kid! It's all gone. Gone!"

It's surely the heightened emotions of the day, and the sleep deprivation, and the feeling that we're living at the end of Time, but Noel, by now, is both apoplectic and hysterical.

"I'm glad to be old school," he declares. "I'm glad I've got ideals and they were taught to me by Bob Marley and John Lennon and John Lydon and Paul Weller and Morrissey and Marr. And now people start bands for a career. Careerism! We never started this band as a career move, we did it cos we were bored shitless and we were all on the dole and this is our life. We never asked for a record deal, somebody gave us one. We never asked for fucking 20 million record sales, it just came, y'knowhatImean?" He springs from the sofa and circles round the back of it, twice.

"The last two, great, working-class things, football and music, they're coaching all the talent out of people," he fumes. "Music should be spontaneous! And football. And all the arts. It's *sinister*. It's 'get me the money, get me it now'. And ten years later it'll be your Greatest Hits. And ten years later it'll be your Greatest Hits Remastered and ten years later it's your Greatest Hits Remastered and Repackaged, and then when one of you dies it'll be your Greatest Hits all over again with sleeve notes by some geezer who walked your dog once. It's all up its own fucking arse, man!"

It's alright lads, "Bob The Builder" is No. 1!

Noel: "I remember when there were good novelty records and nobody gave a fuck. Now, "Bob The Builder" is No. 1 and Mel C's phoning him up wanting to do a duet. A fucking builder and a joiner. All you need is Ronan Keating and you've a builder, a joiner and a fuckin' plasterer! They'd be better off starting their own firm . . ."

It had been a classic Noely G rant. As he swung out the door, satisfied, Liam surveyed the space where his vibrating brother had just been. "Our Kid's a cracker again," he beamed, his face all lit up – *for once* – with brotherly love.

# UNION JACK STUDIOS:

I next shot the band in a more civilized setting, in a studio in Union Street in London. They'd been through a change in lineup by this point, and had been joined by Andy Bell, previously of Ride, on bass. I'd known Andy for years – I first met Noel through him.

This was a shoot of the new lineup for *Uncut*. The folks at the mag wanted a few shots of the band but also some duo and solo shots of Liam and Noel. The brothers knew the drill, of course, and were professional as ever.

This was on a Friday morning and we had a bit of banter going on, especially as I'd known Andy so long. I was saying to him, "Fucking hell, can you do this lot a favour and get them off of The Beatles? They're a brilliant band but there's more than one band in the world…" They were giving it back to me just as strong, as you can imagine; it was five against one.

I had something else on that afternoon, so I had to leave them to it, but they were looking for some suggestions for where to go next, so I recommended a pub or two. I seem to remember Liam making a bit of a weekend rampage of it after that; I'm sure some pictures of him ended up in the *Daily Mirror*.

**1999**

# WHAT YOU GONNA DO WHEN THE WALLS COME FALLIN' DOWN?

It's 2002 and the show must go on, all around the world. *Heathen Chemistry*, Oasis' patchy fifth album, goes to No. 1 (naturally) with No. 2 positions for unexpectedly durable singles, the soaring "Stop Crying Your Heart Out" and the panoramic "Little by Little". Liam's first-ever single release, the whimsically gentle "Songbird" (his homage to Nicole) reaches a respectable No. 3. "I like beautiful things," announces Liam. "It's not all dark in Liam World."

The accompanying world tour is characteristically eventful, including the car crash in Indianapolis involving Noel, Andy Bell and on-tour keyboard player Jay Darlington, where Noel is thrown through the window of the people carrier.

"You're lying on a bed all smashed up," Noel tells me nonchalantly that year in a Manchester hotel room, "and you think, 'If I was Thom Yorke or Fran Healy, I'd have a box set written about this immediately'. But y'see, I can't write fuckin' songs like that [sings], 'Ooh, I was driving down the highway and me face went through the windscreen…' I walked away, what can I say? James Dean didn't."

He carries on, cheerfully. "I'm from the Billy Connolly school of philosophy, it was funny, man," he insists. "I felt sorry for me mam and me daughter, but the worst thing that happened was me favourite sunglasses were smashed to bits and that proper pissed me off: me purple lenses I've had for six years, me Captain Kirks!"

In 2002 Tom Sheehan is with Oasis again, twice. First at Wheeler End Studios, where a robustly alive Noel is working as ever, alongside Gem, and in a photo studio with the full band. Tom's shots this year inadvertently capture an increasingly wobbly band dynamic: no more shots, anymore, of the Gallagher brothers in a single portrait.

By December there's trouble in public, the touring Oasis posse are involved in a Munich night club ruckus with a coterie of estate agents: two front teeth are dislodged from Liam's head, a policeman is kicked in the ribs (by Liam), while an ashtray prangs off Alan White's head, causing minor injuries. With the remaining tour dates postponed until early 2003, payments to German prosecutors for Liam's bail and fine reportedly total £210,000.

"The press say they love to hate us, but in reality, they love to love us," Noel muses to *DW World* in early 2003. "The sad thing is that when they look back over 2002, what they will remember Oasis for is not the fact that we sold over three million records or that I nearly died in a car crash, they'll remember Liam getting his teeth smashed in."

The chaos continues. In 2004 Alan White is sacked, replaced by Ringo Starr's son Zak Starkey, who also drums for The Who, while their Glastonbury headline performance – the sound as muddy as that year's mean fields of Pilton – is deemed "a disaster" by *NME*. Towards its lumbering end a disgruntled Liam, sporting a striking white-fur-collared Parka, kicks his tambourine across the stage, sits hunkered on the stage monitors and blames the flatlined energy on annoying in-ears. An attendee sums up the debacle in the years when The Libertines have become the new rock 'n' roll kids in town: "It was clear from this gig that Oasis weren't Oasis anymore."

And yet, the show must go on, still, all around the world. In 2005 their sixth album, *Don't Believe The Truth,* is released as an unfeasibly zippy return to form, soaring to No. 1 (fancy that), as does the primal roar of "Lyla" and the rambunctious, kinksy "The Importance Of Being Idle". The world tour also proves unexpectedly stable, playing to 3.2 million people across 26 countries, their most incident-free touring adventure in years.

"I've kind of learnt," Noel tells America's *Spin* magazine in 2005, "that instead of arguing stuff out with [Liam] and ending up in a fight, I work on his psychology, and he's completely freaked out by me now. He's actually frightened to death of me."

# 2002–2009

It's the year when Noel first sees a new generation of feverish Oasis fans sprinting down to the front. "There's kids singing along to 'Rock 'N' Roll Star' and they would have been like six when it came out," he notes, astonished. "That took me two months [on tour] to get used to. Before, I wouldn't look young people in the eye."

In 2006, perhaps as a reminder of their world-class musical foundations, Oasis release *Stop the Clocks*, their "definitive songs" compilation, which Noel asks me to contribute sleeve notes to, despite having never walked his dog once. The Brits 2007 brings their Outstanding Contribution award, inspiring Noel to cast his unimpressed eye over fellow nominees.

"Thom Yorke sat at a piano singing, 'This is fucked up' for half an hour," he scoffs to the *Daily Telegraph*, of Thom's Best British Male nomination. "We all know that, Mr Yorke. Who wants to sing the news? No matter how much you sit there twiddling, going, 'We're all doomed', at the end of the day people will always want to hear you play "Creep". Get over it."

He surveys the wider landscape, one dominated by a resurgence in British guitar bands: Arctic Monkeys, The Kooks, Kasabian. "Before we came along, success was a dirty word," he decides. "We kind of reinvigorated ambition. As dumb-arse a message as it was, looking back now, it was, 'Things are shit, so we might as well celebrate something – let's celebrate being young.' There was a euphoria in the music and the way it was delivered, and, as the crowds started to get bigger, it fed off itself until it became less about the band and more about being with all those people, jumping up and down, drunk to the music."

That year Liam is equally reflective: we ponder how the future might unfold, given a part of Oasis will always represent being young and euphoric?

"I can understand that," he nods. "That's the thing that does my head in most about it all: that we'll never be new again. The excitement of being in a new band is second to none. Them first two records are just so important, and nothing can touch 'em. But if it's not as exciting as it used to be, you know when you see an Oasis gig, when we're on form, it's the bollocks."

What would happen to him if Oasis split up?

"I'd go in-fuckin'-sane, wouldn't I?" he decides. "Cos it's your life. I'm dreading the day. But who knows. Just concentrate on one year at a time, one day at a time."

Noel's interviews are now predominantly nostalgic, reflecting on the heady days of debauchery, bedlam and bonkers fur coats, and the moment he realized, *enough*.

"Well, when you look at yourself in the mirror at 7 a.m.," he told *Stuff* magazine, "wearing big fucking round sunglasses and a black fur coat with a fucking 50-pound note up your nose, and you say, 'Yeah, man, this is what it's all about,' you might be a bit fucked. But I'm glad it got like that. We pushed it to the point that it could not get any bigger, could not get any more mad, you couldn't get any more fur in this coat if you tried."

In 2008 he ponders whether he and Liam could ever be considered friends. "If I don't see him from one end of the year to the next when we're not gigging, that's fine by me, and by him," he tells the *Guardian*. "But he's one of the few people who can make me laugh out loud, and vice versa. For someone who's not got a sense of humour, he's hilarious. He's got a weird way with words. Only me and him can say the things we say to each other . . ."

That year *Q* magazine conducts a poll searching for the 50 greatest British albums of the previous 50 years. The jury comes in: *Definitely Maybe* and *(What's The Story) Morning Glory?* are voted No. 1 and No. 2 respectively. Oasis are now immortal. The media, meanwhile, continues its fixation on when Oasis will break up, or, in the case of *Hong Kong* magazine in April 2009, *what* could break them up, if sibling rivalry, unfeasibly, hadn't? Noel considers the options: "Getting bald, fat, someone dies, or I get bored?"

August 28, 2009. Fifteen years after Oasis first threatened to split up in America in 1994 (when Liam pranged Noel in the head with a tambourine, on crystal meth), ten months after the release of their seventh, unremarkable studio album *Dig Out Your Soul*, and the ever-inflating Zeppelin balloon of celebratory rock 'n' roll finally explodes. Minutes before show time at the Rock en Seine festival in Paris, the Gallagher brothers' relationship dramatically self-combusts in a tabloid-anointed "Wonderbrawl", involving smashed guitars and plums pelted at walls. The blame, for Noel, is unequivocal: "I simply could not go on working with Liam a day longer." Perhaps the only surprising thing about the end of Oasis is that this time, definitely, it is the end. In 2011, during promotion for his new band Beady Eye (essentially Oasis minus Noel), Liam briskly addresses, from his perspective, what prompted that fatal Wonderbrawl.

"We got there, went backstage, me and him had an argument about some stupid little twat and that was it," he tells me. "He smashed my guitar that was bought as a present by my lovely wife, signed by my kid. Gene and Nic. But regardless of that, I thought, 'Fuck it. He's been a tit for the last fuckin' six months on this tour.' Blowing hot and cold. I thought, 'Fuck this shit, you're getting one of your guitars.' He got off and that was it."

Puffing hard on his cigarette, Liam carries on.

"I've been around this absurd circus," he announces. "I admit I am a bit of an annoying cunt sometimes on tour. But believe you me, I am not the only one."

Fifteen years after "Acquiesce", I note, it looks like they finally don't need each other anymore.

"Listen, me and him will be sweet, man," Liam decides, unexpectedly. "Our little venture's come to an end but I'll never have a bad word about Oasis, it was fucking amazing. It's why I'm adored by millions! But it's over. And we're buzzin'. And I hope Our Kid's buzzin'. I fuckin' *do*, actually. I hope he's gonna make great records. And he probably will."

By 2023, both Gallagher brothers are now twice-divorced, both in subsequent relationships, both touring artists in their fifties and both individually playing those classic Oasis songs. That year, it's exactly 30 years since Oasis were discovered, by accident, in Glasgow's King Tut's Wah Wah Hut, and almost 40 years since the Gallagher boys moved to their shared Burnage bedroom where those glitter-eyed dreams began, and Noel, as ever, has plenty to say.

"Music of all forms is so fucking middle class now," he tells *The Big Issue*. "Because working-class kids can't afford to buy musical instruments or rehearse or do any of the things we could do. And we were poor. The working-class musician is at the bottom of the pile now. That's why music is shit, because youth culture, 99 times out of 100, comes from the working classes. That's why so many kids now are loving Oasis. Because we were the real deal. And they know the real deal when they see it. A big part of me is really flattered and honoured that Oasis are so popular now. But part of me is a little bit sad that no one came to take our place. No one's come along to speak for them about their lives and their culture and where they're going next."

A year later, in August 2024, news arrives of the Oasis Live 2025 worldwide reunion tour, causing the most frantic clamour for a Golden Ticket since Willy Wonka, while the 30th-anniversary edition of *Definitely Maybe* rockets to No. 1. Their worth, and their singular reach, is now undeniable. After all those decades of chaos and conflict, of celebration and struggle, the songs, in the end, have won.

The songs live forever.

# WHEELER END:

I shot Noel and Gem for a news story – God knows what it was about, though. We went up on the train to Wheeler End, a little hamlet in Buckinghamshire, where there's a recording studio that has been used by the likes of Paul Weller and Led Zeppelin. Oasis took a shine to the studio and supposedly took out a long lease, recording a string of albums there in the late 90s and throughout the 2000s. It was kitted out in psychedelic artwork and, of course, Beatles references.

Because it was just for a news feature the pressure was off, so it was a nice day out, no sweat. I remember we got into a big debate about The Beach Boys. I was making the case for what a great band they were, but Noel and Gem weren't having any of it, saying that they were just a barbershop quartet. Rubbish.

**2002**

# NORTH LONDON:

The last time I shot the band was for the *NME*, as *Melody Maker* had folded by then. The band were giving them a lead interview to promote the *Heathen Chemistry* album and the *NME* designer had an idea for a very graphic approach for a piece, inspired by the psychedelic shots of The Beatles taken by Richard Avedon in the 1960s.

The plan was for me to shoot the band against a white backdrop, holding various bright or interesting everyday items. The designer then worked on the images digitally, using the Avedon shots as a jumping-off point, but in the end looking quite different, a bit more brutal.

They used a nice group shot for the cover with that psychedelic effect and some of the sillier, surreal shots for the piece inside.

**2002**

First published in 2025 by Welbeck
An imprint of HEADLINE PUBLISHING GROUP LIMITED

1

Cataloguing in Publication Data is available from the British Library

ISBN: 9781035429011

Printed and bound in Italy

Headline's policy is to use papers that are natural, renewable and recyclable
products and made from wood grown in well-managed forests and other
controlled sources. The logging and manufacturing processes are expected to
conform to the environmental regulations of the country of origin.

HEADLINE PUBLISHING GROUP LIMITED
An Hachette UK Company
Carmelite House
50 Victoria Embankment
London EC4Y ODZ

The authorised representative in the EEA is Hachette Ireland,
8 Castlecourt Centre, Dublin 15, D15 XTP3, Ireland (email: info@hbgi.ie)

www.headline.co.uk
www.hachette.co.uk

WELBECK